The Lost Book

A Book of Mazes

by
Tim Grotrian
and
Justin Grotrian

Cover Design: David Grotrian
Inside Design: Sam Finocchio
Text Editor: Steve Righthouse
Cover Color: David Grotrian

Visit Labyrinth Productions online at www.labyrinthproductions.net

ISBN: 978-1-4251-5173-7 (sc)
ISBN: 978-1-4251-5174-4 (e)

*Our mission is to efficiently provide the world's finest, most comprehensive book publishing
service, enabling every author to experience success. To find out how to publish your book,
your way, and have it available worldwide, visit us online at www.trafford.com*

Trafford rev. 09/24/2010

 www.trafford.com

North America & international
toll-free: 1 888 232 4444 (USA & Canada)
phone: 250 383 6864 ♦ fax: 812 355 4082

To Veronika, Willow and Claudia

Table of Contents

I. Maze
Instructions

MAZE INSTRUCTIONS

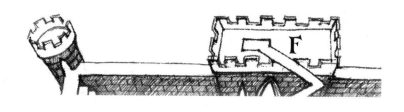

S The start of the maze is always indicated by the letter S.

The goal of each Maze is to get to the finish, which is indicated by the letter F.

You can follow any path that is clear, but if there is a barrier or an obstacle, such as a wall or a closed door, or the path simply ends, you must turn around and seek a new path.

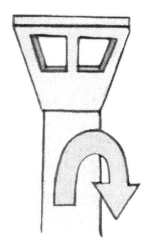

MAZE INSTRUCTIONS

Because the Mazes are built on different levels, you may think a path has ended ~ only to see that it is actually going underneath a ramp or another path. If this is the case, then the path is not blocked and you may follow it.

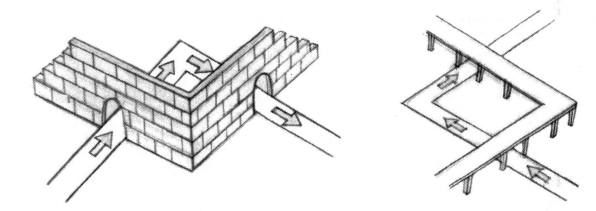

In this example, you are going through a castle entrance.

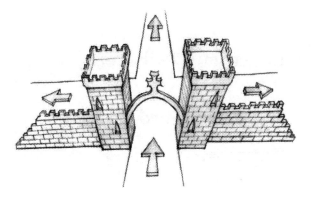

MAZE INSTRUCTIONS

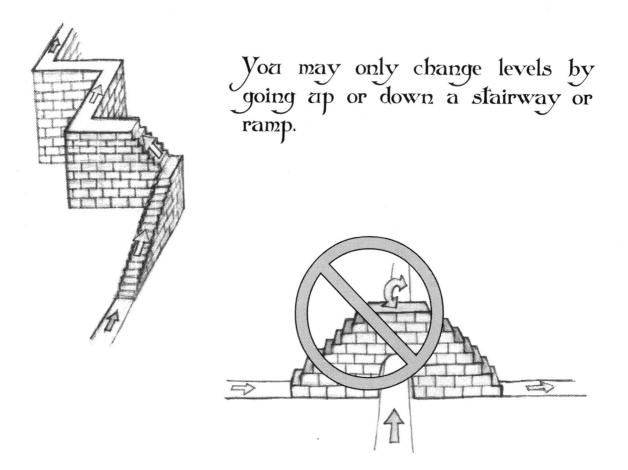

You may only change levels by going up or down a stairway or ramp.

Only stairs or ramps can take you from one level to another. You may not simply jump to a different level.

Pits are dead ends from which you can't climb out. They look like this and are marked with the word Pit!

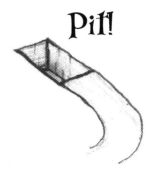

Pit!

MAZE INSTRUCTIONS

The exception to using stairs is that if some object such as a rope or ladder can be used to reach another level, you may use it just as if it were a stairway.

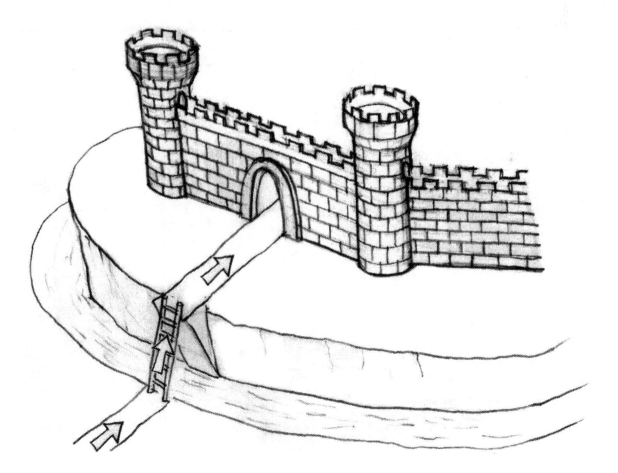

MAZE INSTRUCTIONS

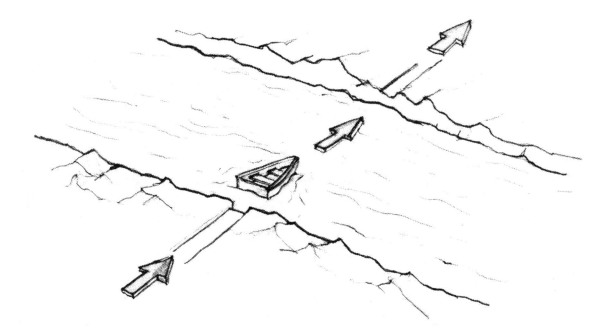

You may use a boat or fallen log to cross water.

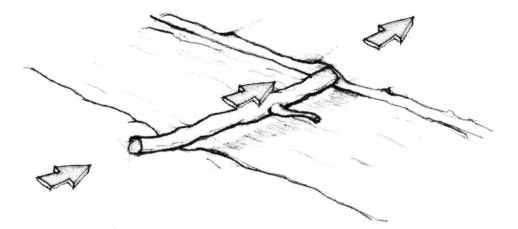

MAZE INSTRUCTIONS

Stairs may be seen from a profile (side) view. They are still part of the maze path and can be used to reach the finish.

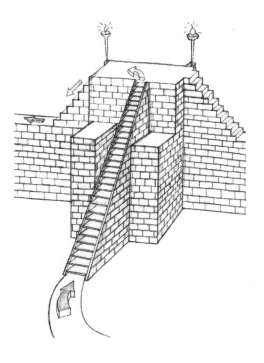

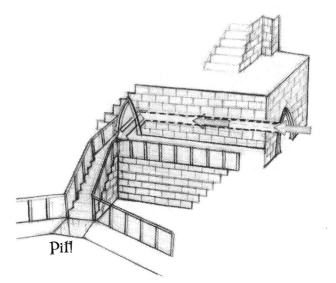

Pit!

Dashed lines are used in architectural drawings to denote something that is hidden. In the Mazes, dashed lines indicate paths that are hidden, such as underground paths and secret passageways.

Finally, there may be more than one solution to a Maze!

II. The Mazes

Water Castle

Samantha of Venice has been hearing rumors that her friend Melissa of Bavaria is suffering from a strange illness that has her family and doctors baffled. Samantha has requested a letter from Melissa's doctor explaining her condition. You are a messenger who has been appointed to deliver this important missive to Melissa's friend. The canals around and through the castle will take you to Samantha's living quarters in the back.

Deliver the letter!

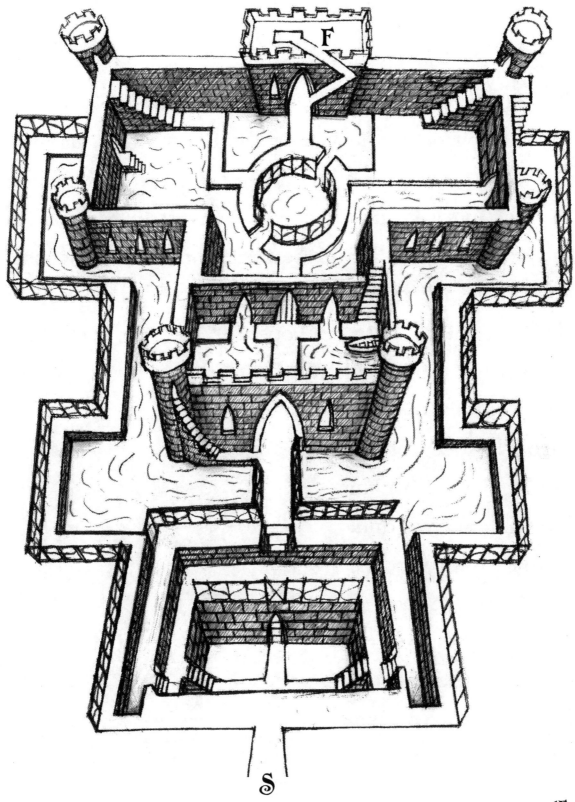

F

S

The Eyes of Claudia

During the day, Claudia is a quiet, shy girl, who goes to school, and loves her studies of music, art and literature. As one of her classmates, you are longing to meet this beautiful girl. You know that she likes to go for long walks in the forest around her village, so, on a beautiful fall evening, you walk along a path that she might take, in hopes of meeting her. You walk and wait until, finally, you see her, and call out, "Claudia!" As she turns to face you, she has the wind in her hair, the fall leaves dance erratically around her, and you see not the shy eyes of the quiet girl you are used to, but ~ a look you have never seen before!

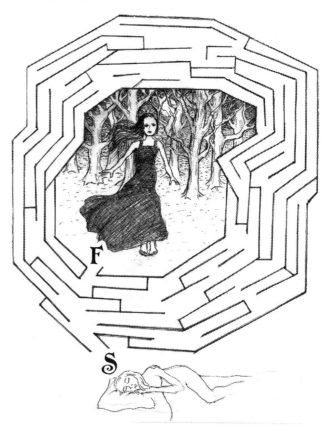

16

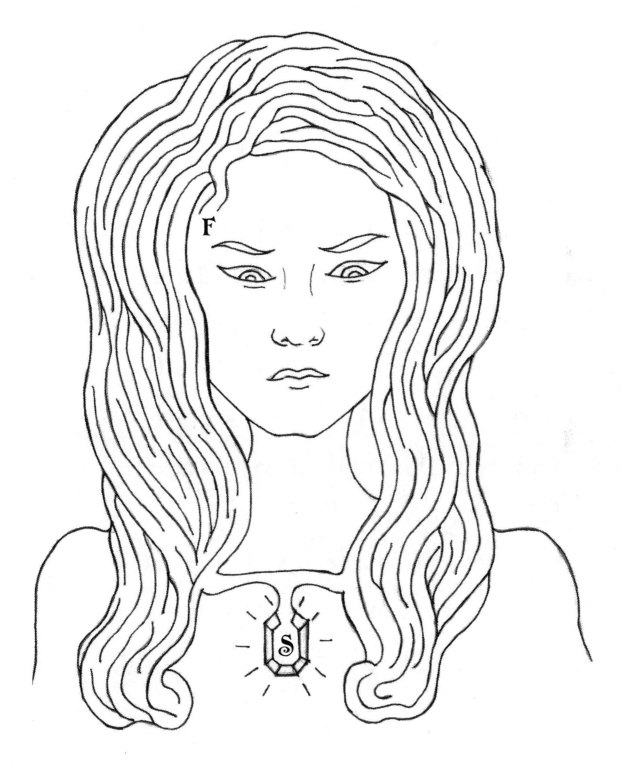

The Mummy's Curse

By a wavering flame in my dank tomb,
I wait ~ to see you to your doom,
When, curious about the age~old myth,
You enter here and draw a breath
Of musty air ~ the candle's glare
Dimming in the fetid atmosphere.
Before you see me, I'll be there,
And have you by the neck and hair,
And those last moments granted you
Will be your proof ~ the myth is true!

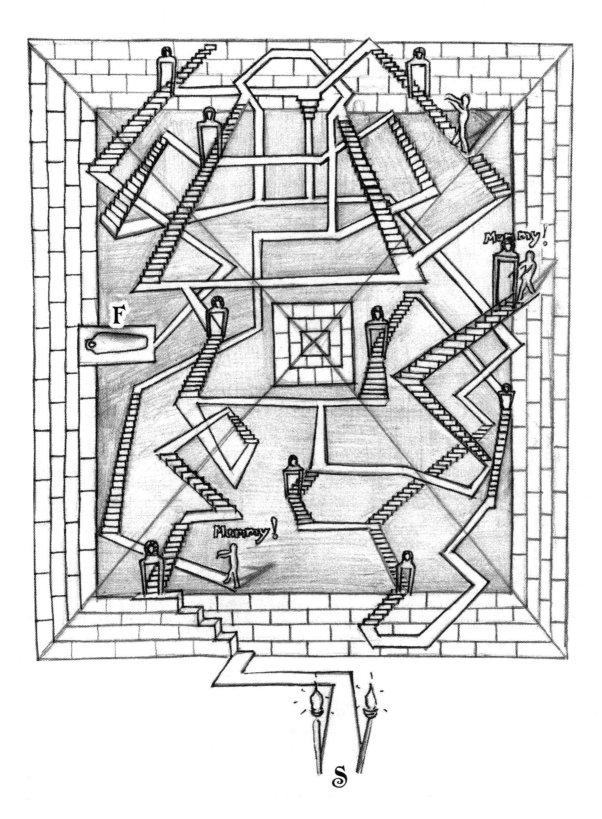

The Count

The count has not allowed his beautiful wife to leave the grounds of his castle since they were married a year ago. At first, she was happy, roaming the spacious gardens there, but her growing desire to see her friends in the village made the count so jealous, that he forced her into a dungeon, and he keeps her under guard from the main tower.

You have not seen your friend since she married, so you go to the castle to visit her. It is early evening, the torches at the castle entrance are lit. You make your way to the courtyard, with its reflecting pool, and see the count, high up in his tower. Yelling up to him, you ask to see your friend, whom you've not seen for so long. He yells back, "She no longer lives here."

Puzzled, you turn to leave, when your eye is drawn to an image in the pool ~ it is your friend reflected there! She is in the castle, after all! Find her!

20

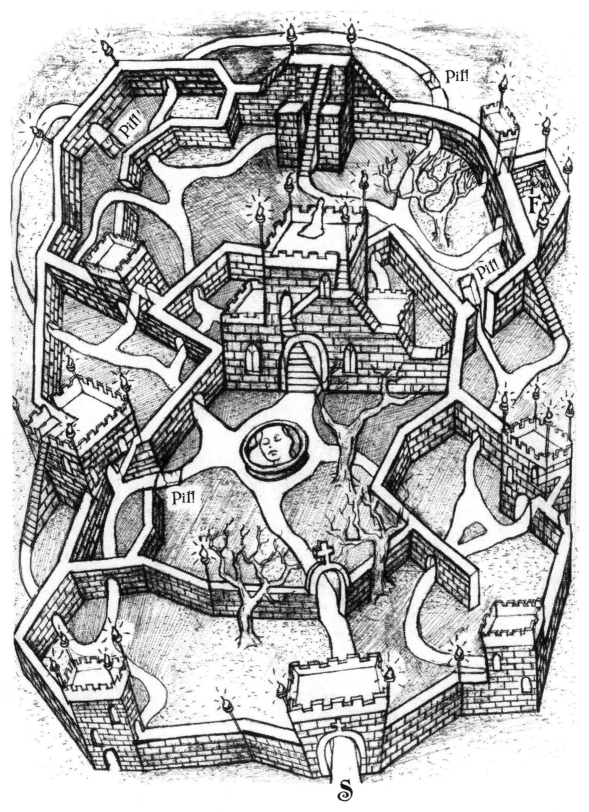

Night Castle

In the mountains of Transylvania, there is a castle, which, according to folklore, is the home of Claudia, the lone descendent of the great and terrible Vlad the Impaler. The townsfolk in the village below will not go near this fortress, especially at night, because, as the story goes, that is when she is awake and roams the countryside. You are fascinated by this story, and have traveled from America to test its veracity. Racing clouds veil the full moon's face as you enter the castle in search of this mysterious girl.

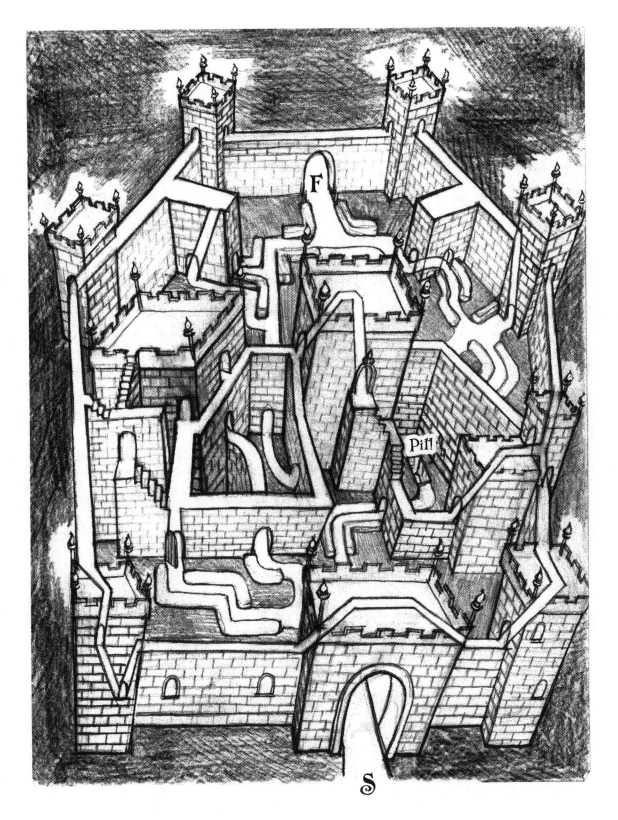

The Crying Girl

The count has moved his wife to a secret fortress in the Black Forest of southern Germany, where the great pine trees tower overhead like a magnificent cathedral, and the needles they shed form a plush carpet covering the ground. Inside his fortress he leads her down long corridors, and through winding tunnels, before finally locking her in the darkest dungeon in the castle. She has been sobbing ever since. As you walk past his castle one evening, you hear the muffled cries of his suffering wife. You cannot stand it when a person is in pain ~ try to rescue the crying girl!

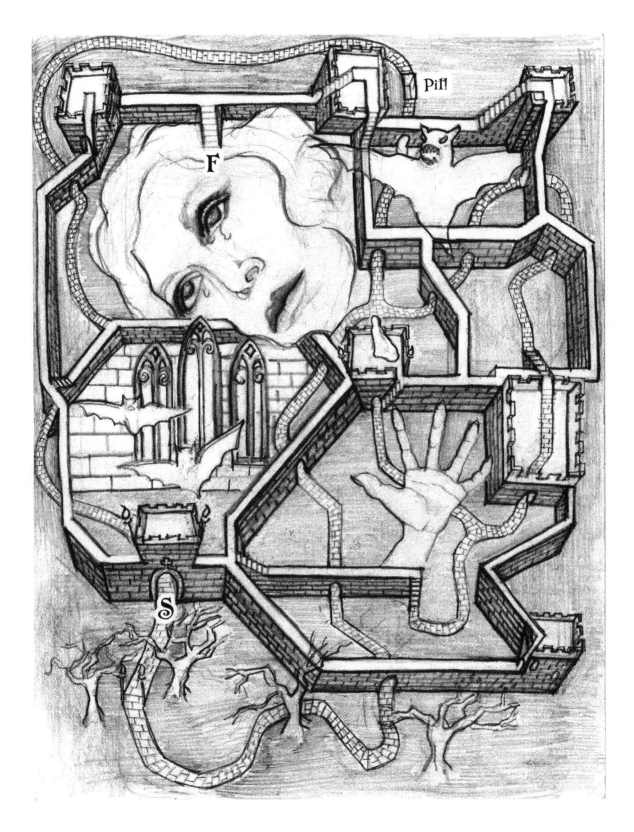

The Count's Revenge

You have rescued the count's wife, and taken her to your castle, where she has been happy beyond her wildest dreams. She wants to live with you forever, but the count has other ideas. Now, you have had to go to France, and the count has seized his chance to steal back his bride!

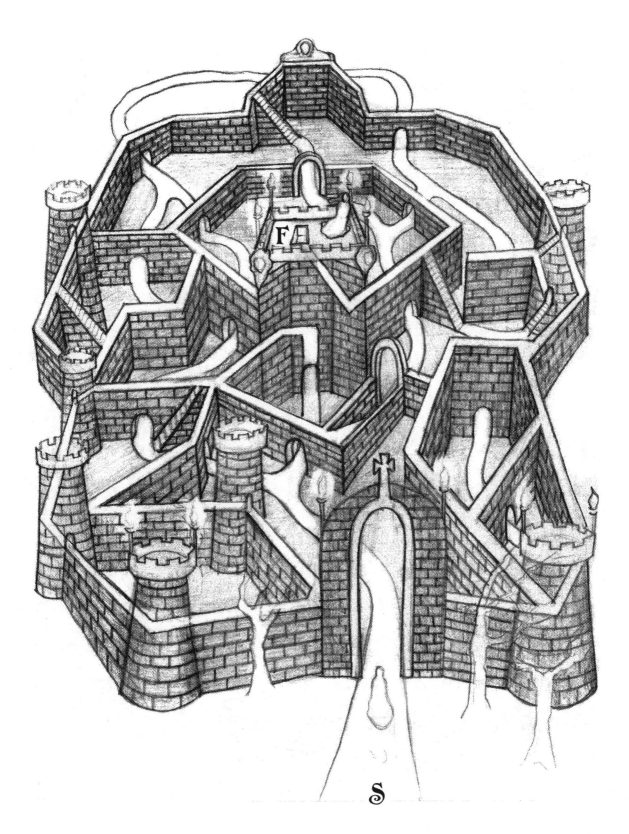

F A

S

Crystal Ball

Samantha has a powerful crystal ball which allows her to see into the future. This crystal ball is the envy of all the Young Witches, and they have tried to convince her to relinquish it, arguing that she does not yet know how to fully exploit its power. Her friend Veronika has told her that, whatever she does, she must not yield to the witches' demands to give up the crystal ball. A fortress has been built to protect it, but the young witches are conspiring to steal the crystal ball from Samantha. See if you can find the path that leads to the crystal ball!

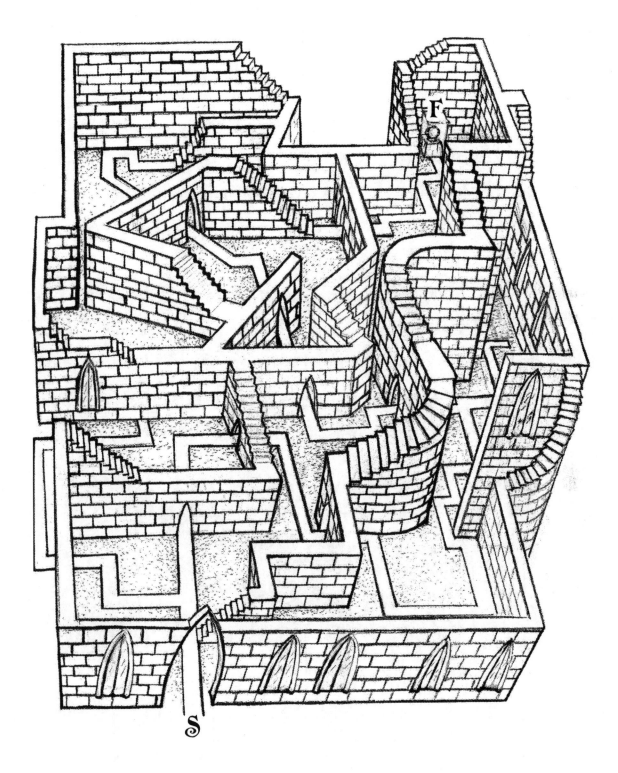

The Emerald Fortress

Not only does Samantha possess a powerful crystal ball which allows her to see into the future, her reclusive Aunt Silvia has also given her a beautiful emerald, which Samantha knows has untold powers. Believing these powers to be great, her friends Veronika and Laura have convinced her to build a fortress to house the emerald, just like they did with the powerful crystal ball. The Young Witches are also convinced, and they have come to the Emerald Fortress to find this strange and beautiful gem.

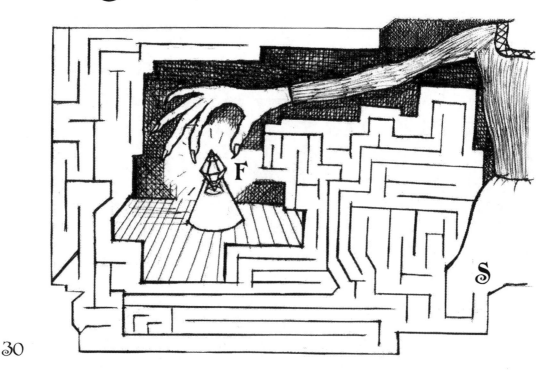

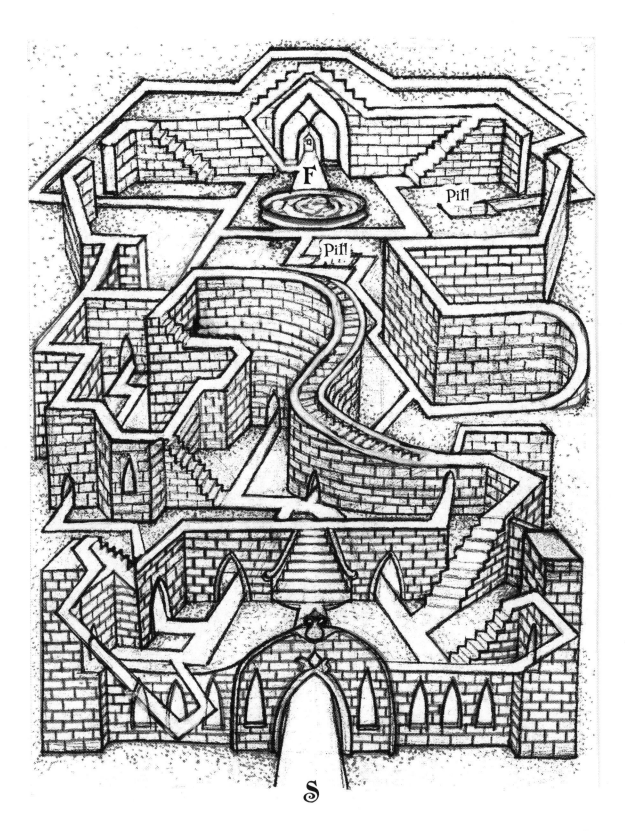

Night Messenger

Herr Konrad is a rich recluse with powerful enemies. He has, therefore, built his castle on a mountain, and around it, a wide moat. Winding roads and deep pits complete the puzzle, making him practically unapproachable.

A plot to rob Herr Konrad of his riches has come to light, and you have been chosen to warn him, so that he can take measures to protect his wealth. You decide to go at night, to avoid being seen by his enemies. Beware though ~ the paths are poorly lit, and the pits quite deep! In spite of these dangers, you must deliver the message!

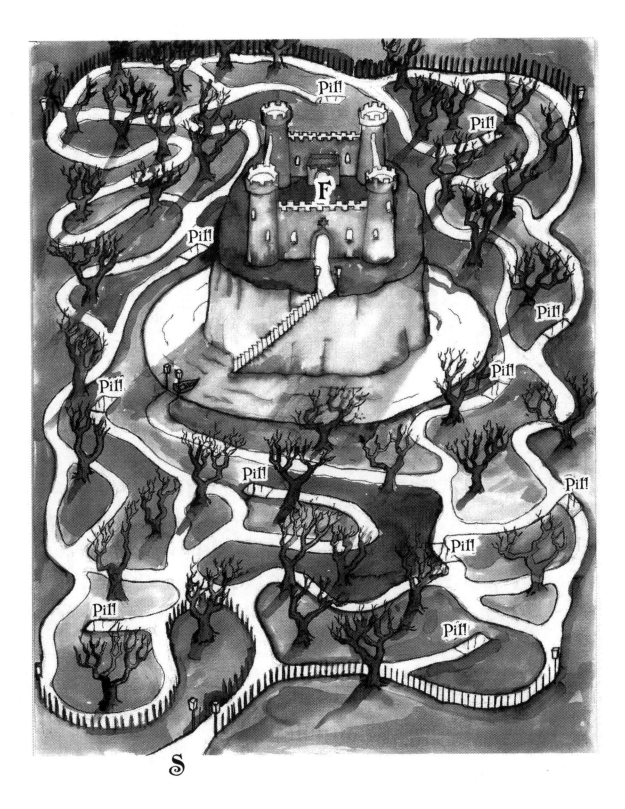

The Dancer's Shoes

adia was a beautiful Russian ballerina, who thrilled the audiences of Europe from Spain to Norway. It was in Berlin, during a performance of Tchaikowsky's "Swan Lake," that she suddenly collapsed. The audience watched in silence as Nadia had to be carried from the stage. The next day the people of Europe were shocked to learn of her death. Now her grave is a national monument in St. Petersburg, and locked away in that monument are her fabled shoes. Many dancers believe that the shoes possess a magical power. One dancer in particular, the tall and beautiful Alexandria, believes that if she possessed the shoes, she would be even greater than the famous Nadia. She has waited until nightfall, and now, under the cover of darkness, she hopes to find the chamber where the shoes are hidden, so that she can become the greatest dancer of all!

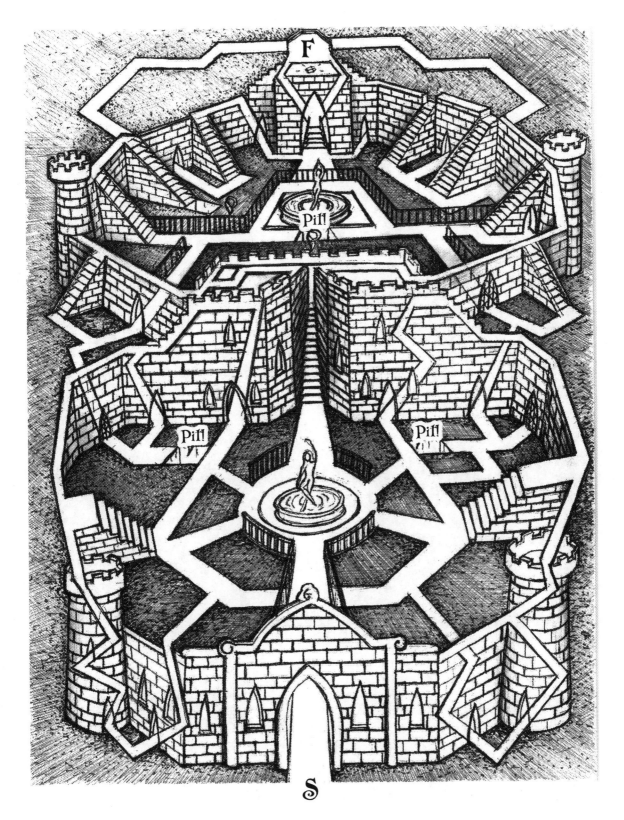

35

Melissa's Morning Walk

Little Melissa always loves the time she has to herself in the morning. Especially in the Spring she likes to go barefoot in the fresh green grass, and feel the soft spring breeze in her hair. On this particular morning, however, she notices during her walk that the gentle breeze has become a strong wind, which is getting stronger by the minute. She knows a storm is on the way! Help her get home before the storm hits!

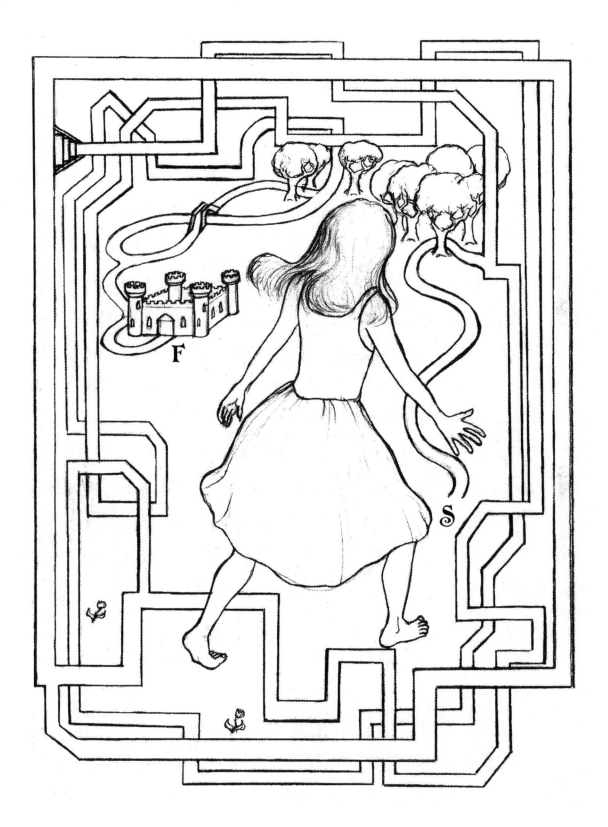

The Dark Garden of Melissa

Melissa was the beautiful daughter of a king who long ago ruled a province in Germany. One day, she became very ill after being caught in a storm during a morning walk. Her mother, the queen, watched after her daughter day and night, but Melissa still grew weaker. One night, her mother lit the candle next to her bed, and read her a story. After reading, her mother went to blow out the candle. Melissa, however, asked her to leave the candle burning, because there was "warmth in the flame." "Certainly, my dear," said the mother, and she kissed her daughter good night. When the mother came into the room the next morning, her daughter and the candle were gone!

Now, many years later, the castle is abandoned, and the king and queen are dead. But townspeople tell the story of a little girl who can be seen wandering at night through the castle's overgrown gardens, in her hand, a flickering candle!

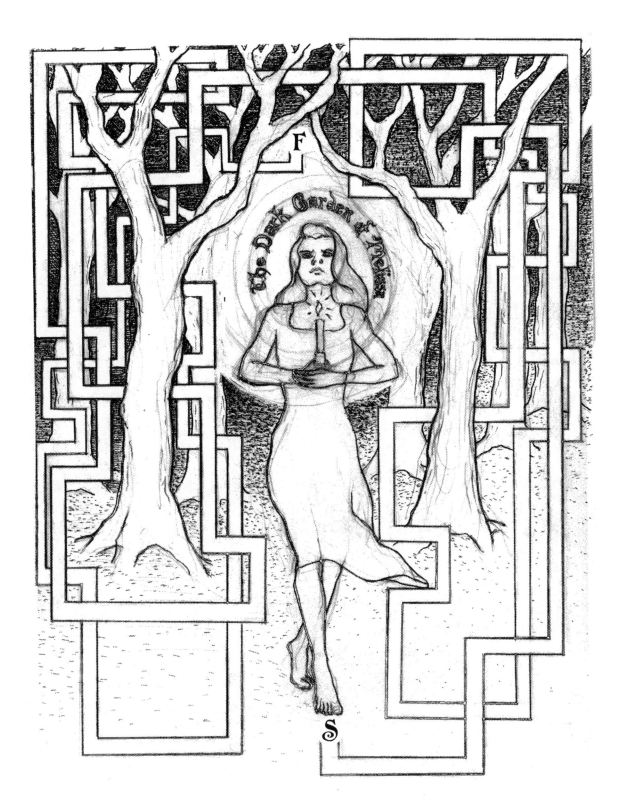

The Dark Garden of Ezekiel

The Strange Glow

Walking past the expansive mountain retreat of Mr. McClintock (famous for his "House of Mirrors"), Max spies an open entrance. Seeing no one, he goes to the door and shouts, "Is anyone there?" Getting no answer, he looks inside, and, curious as to whether there are any mystery mirrors in this house, he begins to make his way through, when he notices a strange glow coming from a room in the back. What could it be?

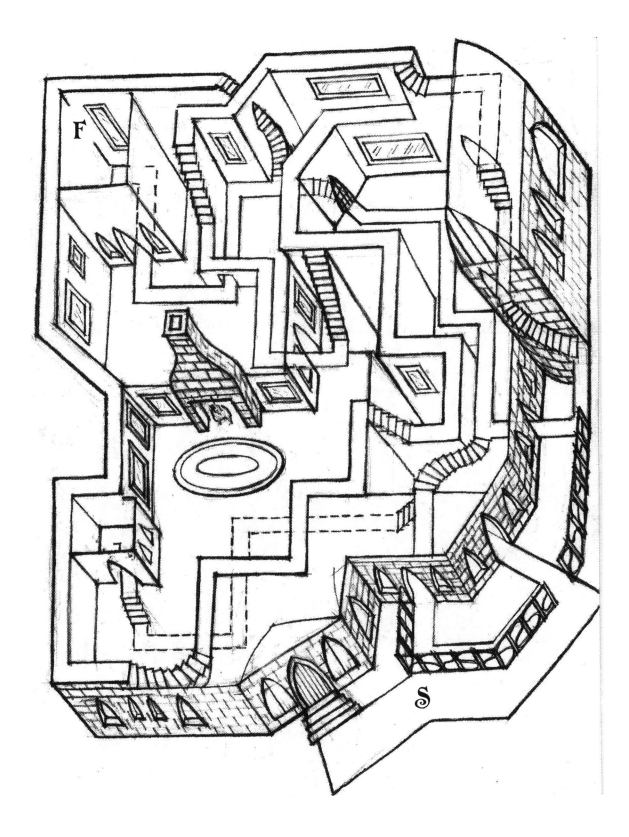

41

Approaching Storm

azing at the source of this strange glow, Max is transported to a wind-whipped forest. Trees lean and groan... leaves swirl about him... but Max's thoughts are steady and clear: he must get word to the reclusive Mr. Cardwell that a client of his needs immediate help. The gathering storm has knocked out all phone service and threatens to extinguish Max's candle. Can you help him find his way?

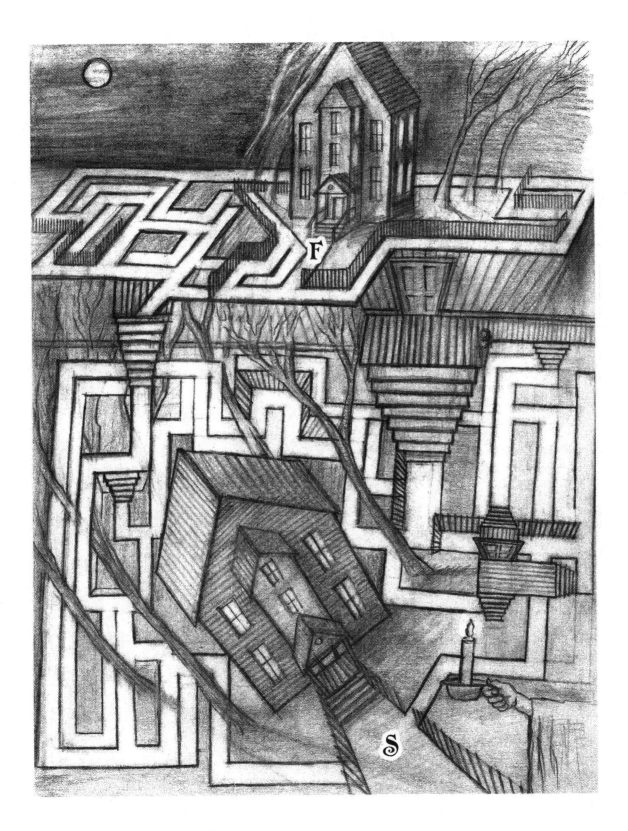

43

The Ring

Samantha has come to realize just how powerful the jewels that were given to her by her reclusive aunt are. She has, among her collection, a ring with a sapphire stone so powerful, that it will hypnotize anyone who so much as glances at it. (Samantha and her friend Melissa found this out one day, quite by accident, when Melissa fell into a trance as Samantha was trying on various pieces of her jewelry. Needless to say, the ring has no effect on Samantha.) In order to protect the ring, Samantha has locked it away in her parent's country castle. The Young Witches are after this magical gem, along with all the other jewels that came from Samantha's Aunt Silvia. The witches have found the castle, and will try to make their way to the vault in back, where the ring is locked away!

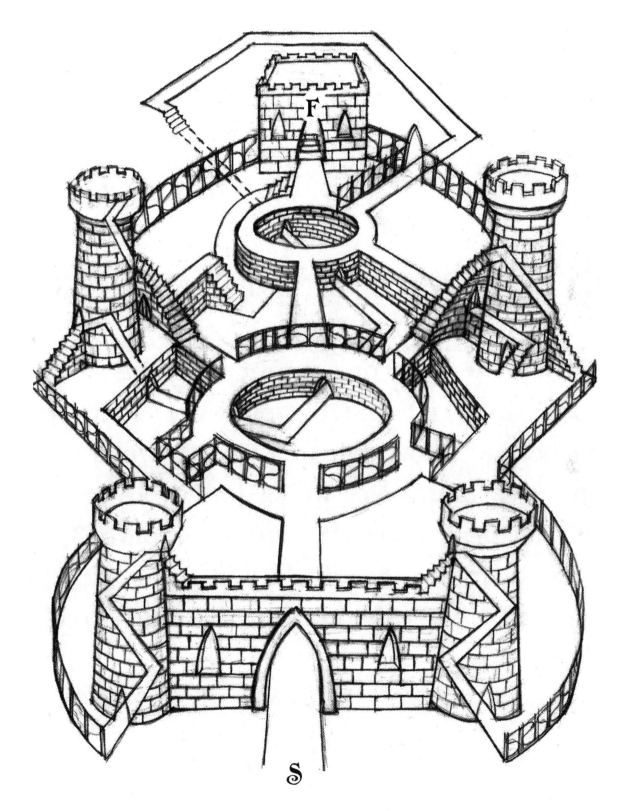

The Forbidden Staircase

There's an abandoned house in the forest near your village. You have heard stories about people wandering into this house and climbing the stairs ~ never to be heard from again! You are unafraid, however, and decide to get to the bottom of this mystery yourself. Take the path that leads from the door to the top of the stairs, and see who ~ or what ~ is living there!

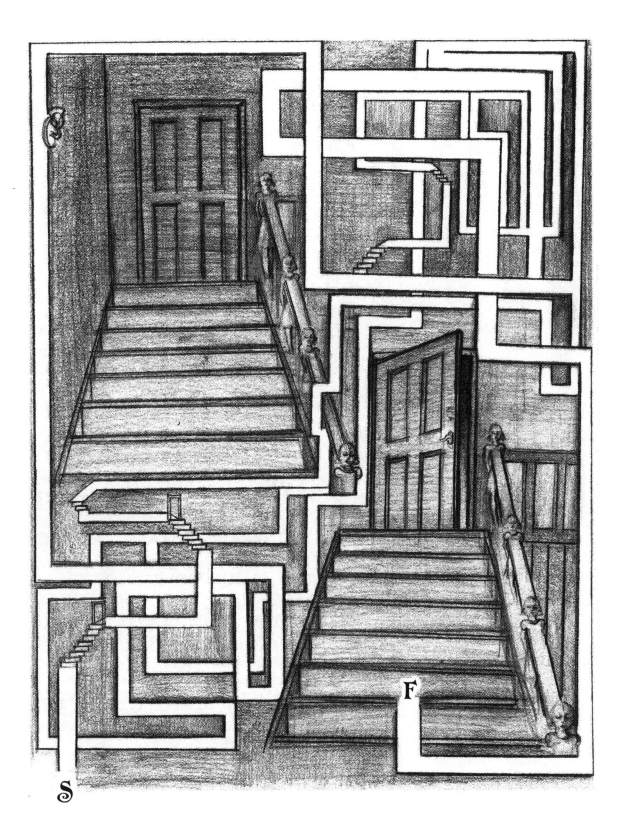

Mr. Ziegler's Safe

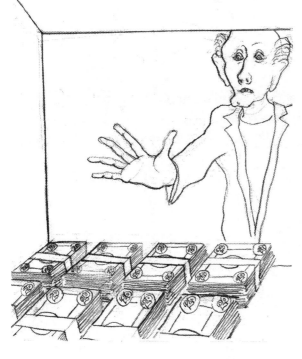

Mr. Ziegler is a well~known miser, who keeps his money in a safe at the back of his house. (He doesn't believe in banks.) He hardly ever leaves the house, because he doesn't want to leave his money. On one particular afternoon, however, you know that he is gone, and decide that this is your chance. Start at the entrance and see if you can find his safe!

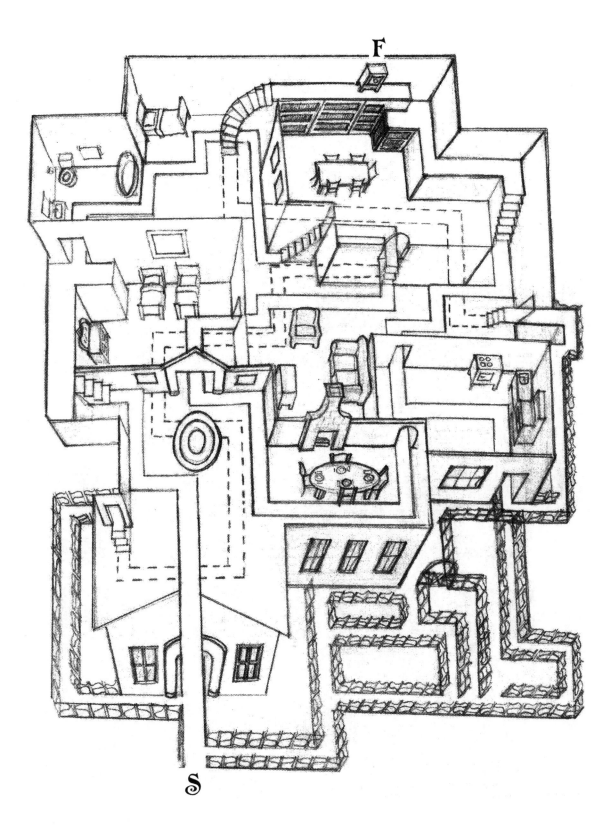

49

III. The Solutions

Water Castle

The Eyes of Claudia

The Mummy's Curse

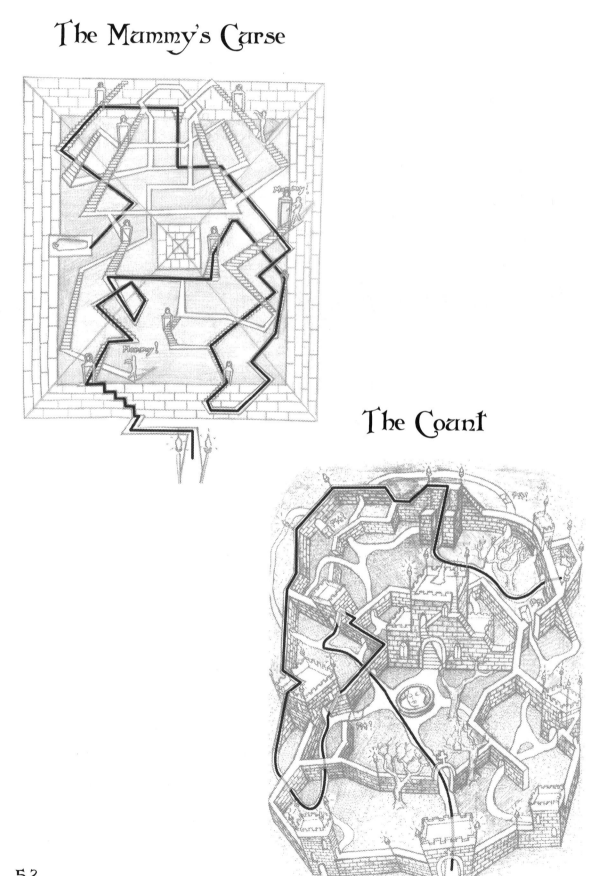

The Count

Night Castle

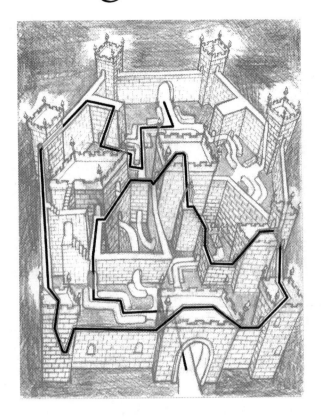

The Crying Girl

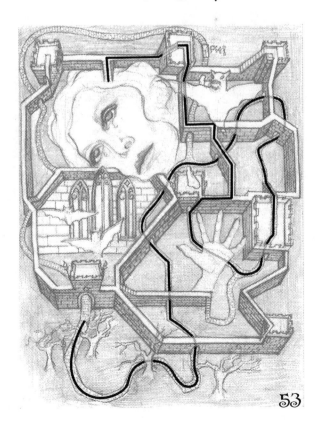

The Count's Revenge

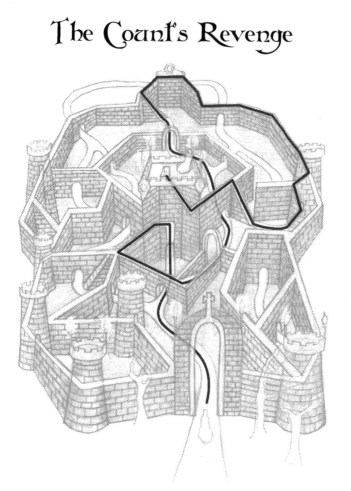

Crystal Ball

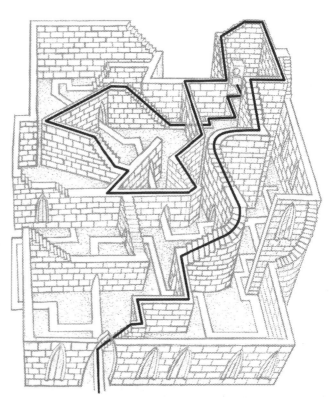

The Emerald Fortress

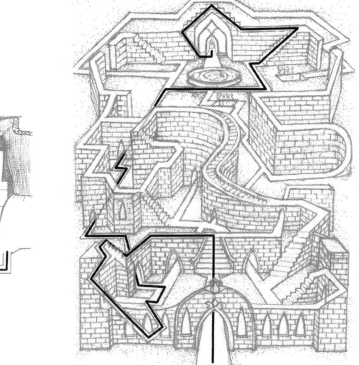

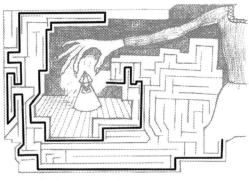

Night Messenger

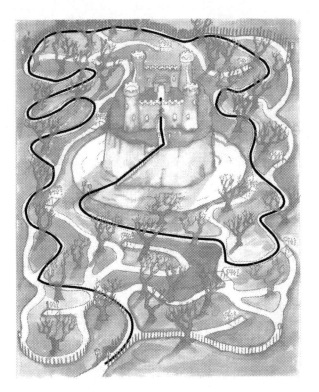

The Dancer's Shoes

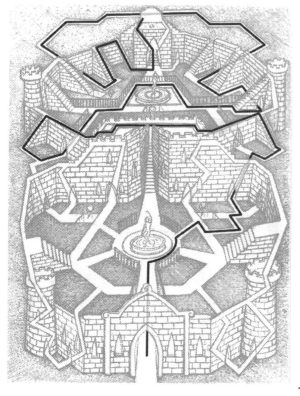

Melissa's Morning Walk

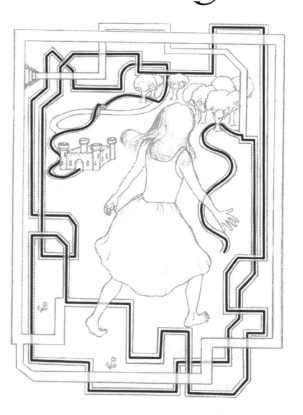

The Dark Garden of Melissa

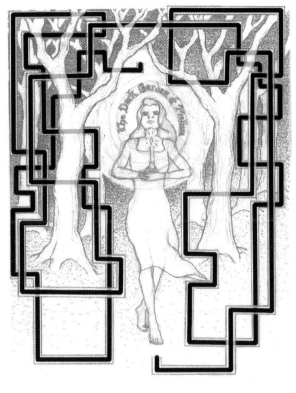

The Strange Glow

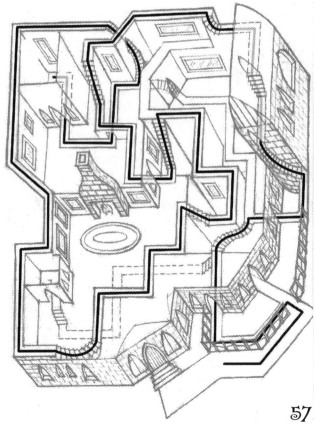

Approaching Storm

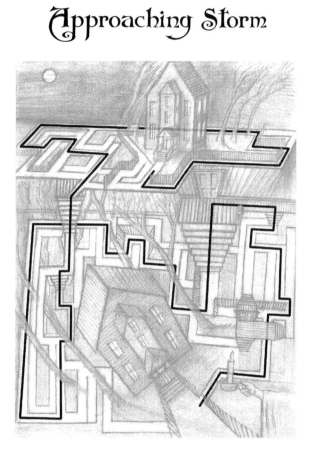

The Ring

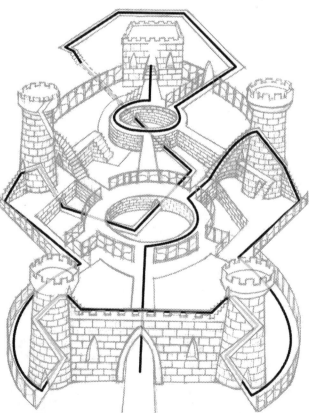

The Forbidden Staircase

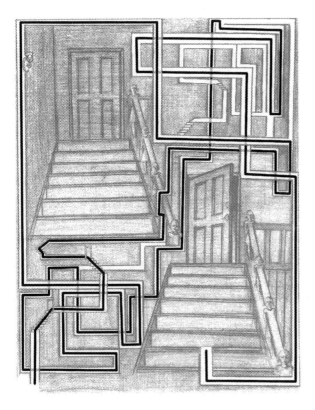

Mr. Ziegler's Safe

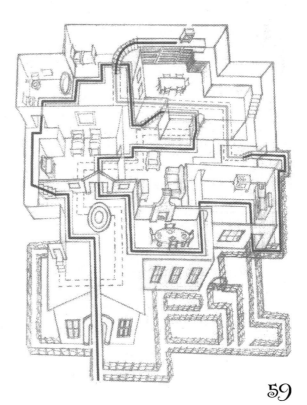